101 Things to Learn in Art School

The MIT Press Cambridge, Massachusetts London, England

101 Things to Learn in Art School

Kit White

First MIT Press paperback edition, 2024

© 2011 Massachusetts Institute of Technology and Kit White

This book was set in Adobe Garamond and Gotham Condensed by the MIT Press. Printed and bound in the United States of America.

Cover illustrations based on Jeff Koons, *Puppy*, Bilbao, 1992–1994, and Marcel Duchamp, *Fountain*, 1917.

Library of Congress Cataloging-in-Publication Data

White, Kit, 1951–
101 things to learn in art school / Kit White.
 p. cm.
ISBN 978-0-262-01621-6 (hardcover : alk. paper), 978-0-262-54746-8 (pb.)
1. Artists—Training of. 2. Art students—Psychology. 3. Art schools. I. Title. II. Title:
One hundred one things to learn in art school. III. Title: One hundred and one things to
learn in art school.
N325.W49 2011
707.1—dc22
 2010047667

10 9 8 7 6 5 4

To Andrea and Philippa, who light up my days.

Author's Note

Art is an idea that belongs to everyone. It is found in every culture. Whatever physical form it might take, whatever emotional, aesthetic, or psychological challenge it may offer, it is vital to every culture's sense of itself. I have tried to keep this thought in mind as I developed the content of this book, for although art students and teachers might be its most natural readers, the practice of "art," per se, is not a prerequisite to reading this book. Lessons learned in pursuit of art are lessons that pertain to almost everything we experience. Art is not separate from life; it is the very description of the lives we lead. And so, this book is really for everyone who cares about art and the way it enriches our being.

Humans have been producing art objects for tens of thousands of years, but art schools are a relatively recent phenomenon. Traditionally, artists received their training as apprentices to working artists or in ateliers presided over by a master. But the contemporary art school, as part of a larger liberal arts education, is an altogether different experience, reflecting the ways in which we have come to understand art as an extension of our daily culture. Art is everywhere. The way we make it, look at it, and analyze it is ever-evolving. It is that constant, ceaseless, *becoming* and transformation of art that has determined this book's content; some of the lessons have to do with ways of making and representing, but just as many remind us of the necessity of searching, knowing, and doubting.

As a teacher, I still believe that technique has an important place in art education because artists are, at their core, makers. One has a different understanding of an image or object, how it does what it does, if one knows the details and processes of its creation intimately. This is one reason imitation has always been a part of artistic training. Artists assimilate a whole range of psychological, aesthetic, political, and emotional data points, and they then make forms to organize and give meaning to them. That takes skill and practice, working in

tandem with intelligence and keen observation. But without the tools to fashion the form, it is like trying to capture air with a net—and often about as effective. Basic form-giving skills help the student make the bridge between thought and embodiment. Because existing art is the best manifestation of artistic ideas, I chose to illustrate the lessons in this book with images based on historical and contemporary works of art—to give each idea, lesson, or conceptual "thing" a visual correlative or apposite image. These drawings, with their imperfections and distortions, are mine, and as such they serve as demonstrations of what the words are largely about: how we learn through observing and attempting to capture ideas that were often originally and successfully executed by others. If my allusive drawings illustrate just how difficult it is to replicate the subtlety and nuance of another artist's image, this should be taken as a humble acknowledgement of the difference between what a real work of art does and what an imitation accomplishes. These images are in no sense meant to be substitutes for the originals on which they are based, except for those that are my own work, or to imply agreement by the artists with the statements I have made. They are simply visual referrals to artists, ideas, and works that I believe art students should know and others

might want to consider. Notwithstanding these qualifications, I am grateful that so many artists whose works I represented expressed their understanding and approval of my intent, and I appreciate their willingness to be my collaborators, in that sense.

When I was an art student, I never imagined becoming a teacher. I was focused only on becoming a maker. My feelings then mirrored the sentiment attributed to George Bernard Shaw, "He who can, does; he who cannot, teaches." I discovered after a couple of decades of practice, however, that all of those critical, initial discussions that rose out of the need to know and the passion to do became increasingly less a part of the conversations I was having with my fellow artists. I missed the exercise of going back to the beginning, reexamining basic premises, asking first questions. As the ability to gain new perspectives at each turn in the road became more difficult, more distant, I began to reflect on the things we discussed in art school and on why those conversations should never stop. The issues we encounter as students of art are life lessons and should always stay with us. Without them, we are not students of life.

Kit White
March 2011

Acknowledgments

I had not entertained the idea of writing this book until Roger Conover suggested it to me. At first, the idea struck me as both impossible and challenging. I remained reticent until, after a few months of making notes, the project took on a life of its own, and I became intrigued by its possibilities. This book is a product of numerous conversations and debates with Roger, in person and at a distance, over several years. Throughout, his persuasion and support made this a true collaboration. My special thanks to Andrea Barnet, whose steadfast ear was always with me; William Fasolino, who showed me by example what it meant to be a dedicated teacher and who gave me my first opportunity to teach;

Donna Moran, who opened many doors for me; my readers: Kurt Andersen, Jack Barth, Pier Consagra, Patricia Cronin, Rochelle Gurstein, Deborah Kass, Dana Prescott, and David True; William Strong, who guided me through the finer points of copyright; Deborah Cantor-Adams, whose diligence and careful eye assured the integrity of my text; Yasuyo Iguchi for her elegant design; Janet Rossi, who managed this book's production; Anar Badalov, who responded to all queries before I could finish them; and especially all of my students, who have taught me far more than I have taught them.

101 Things to Learn in Art School

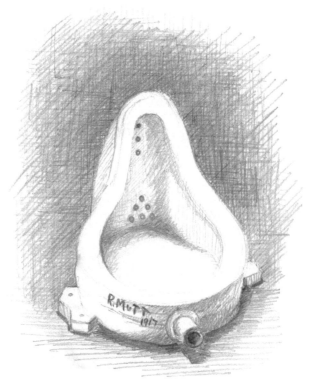

After Marcel Duchamp

1

Art can be anything.

It is not defined by medium or the means of its production, but by a collective sense that it belongs to a category of experience we have come to know as "art."

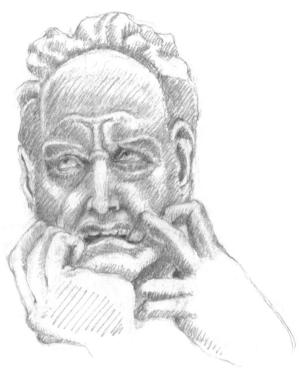

After Jean-Baptiste Carpeaux

2

Learn to draw.

Drawing is more than a tool for rendering and capturing likenesses. It is a language, with its own syntax, grammar, and urgency. Learning to draw is about learning to see. In this way, it is a metaphor for all art activity. Whatever its form, drawing transforms perception and thought into image and teaches us how to think with our eyes.

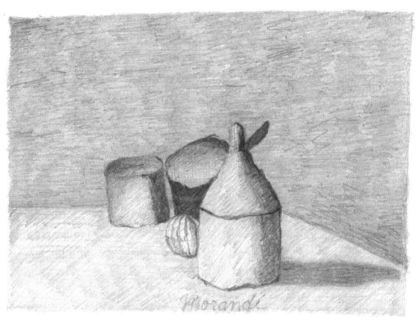

After Giorgio Morandi

<div style="text-align: center">

3

</div>

"To return to things themselves is to return to that world which precedes knowledge, of which knowledge always speaks."

—Maurice Merleau-Ponty, *Phenomenology of Perception*

Whatever we know, we know from the world that surrounds us. Art studies the world, in all its manifestations, and renders back to us not simply how we see, but how we react to what we see and what we know as a consequence of that seeing. The world is the source of all of our relationships, social and political as well as aesthetic. Art is a part of the world, not apart from it.

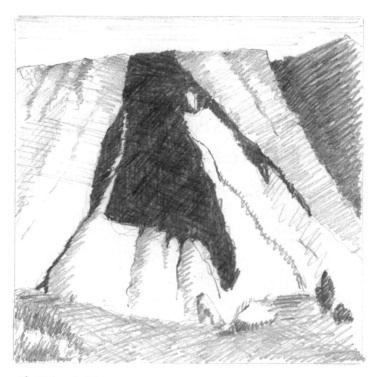

After Robert Smithson

Art is the product of process.

Whether conceptual, experimental, emotional, or formal, the process you develop yields the image you produce. The materials you choose, the methods of production, and the sources of the images should all reflect the interests that command your attention. The process does not stop with each work completed. It is ongoing. The cumulative result of that process is a body of work.

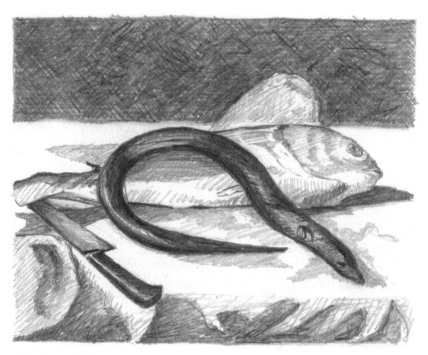

After Edouard Manet

5

A drawing (or a painting, photograph, and so on) is first and foremost an expression of its medium.

The medium is the artwork's first identity. It is secondarily about what it depicts. Form shapes content. A poorly executed image remains insignificant. A well-constructed image of something seemingly insignificant can be masterful. In all great work, the subject and the means by which it is rendered are inseparable. Master your technique to protect your content.

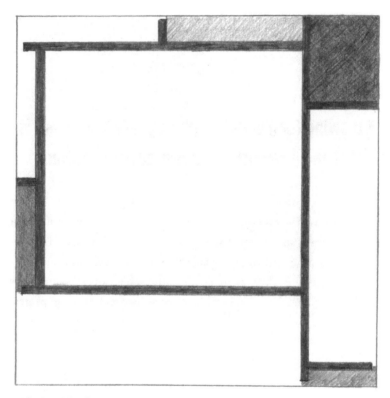

After Piet Mondrian

$$\boxed{6}$$

Composition is the foundation of image making.

It is the spatial relationship between all of the parts in an image. Whether a drawing, a painting, a sculpture, a photograph, a video, or an installation, how a thing is composed determines its look, its feel, and its meaning. Compositional variation, like musical tunes, is limitless.

After J.M.W. Turner

7

"Tradition is the record of imaginative experience."

—Kathleen Raine, *Blake and Tradition*

The tradition of art making is not the same as "traditional" art. The former is the record of exploration; the latter is the product of exploration in a particular time and place. Art describes the world in which it is made. That is its value to us. It tells us where we have been and where we are.

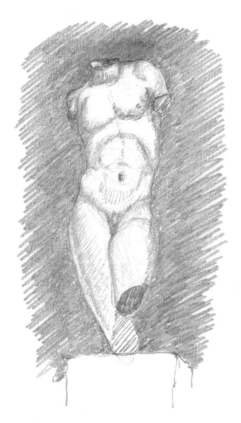

After fourth-century BC Greek sculpture

8

Art is a continuing dialogue that stretches back through thousands of years.

What you make is your contribution to that dialogue. Therefore, be conscious of what has come before you and the conversation that surrounds you. Try not to repeat what has already been said. Study art history and stay alert to the dialogue of your moment.

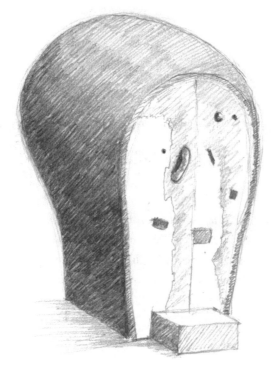

After Martin Puryear

<div style="border: 1px solid;">

9

</div>

Art is a form of description.

How it describes is its form and what it describes is its content. When looking at your work, ask, "What does this describe?" And then, "What form should that description take?" Be flexible in deciding the medium you choose; it must be appropriate to what you are saying. Choose the right form for the content.

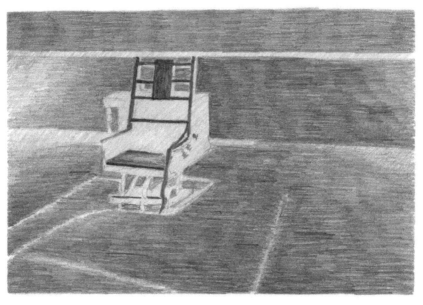

After Andy Warhol (drawn by Kit White)

Art is not self-expression.

It is the self expressing all of the elements of the culture that has shaped it. We filter the ambient information that surrounds us—from our families, from our communities, from the information that bombards us every day from myriad sources. We do not create this information; it helps to create us. We in turn start to interpret it and describe it to ourselves and to others as a means to understand it. This is the art impulse. Even works of pure imagination have sources outside of ourselves. Know your sources.

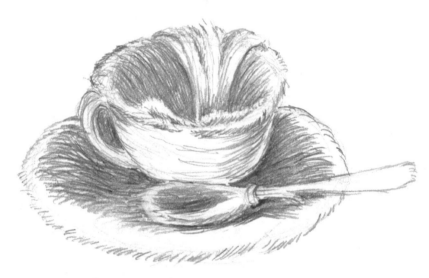

After Meret Oppenheim

11

"All art is quite useless."

—Oscar Wilde

Art isn't utilitarian, and if it is, perhaps it isn't art. Art serves a non-practical role in our lives, but that does not mean that it is not vital or necessary. One's individual identity and our collective identity as a culture have no clear serviceability, but they are critical to our ability to function as a society.

After Jan Groth

Perception is a reciprocal action.

Viewers bring to the act of seeing individual sets of conscious and unconscious reactions that affect their response to the visual stimulus put before them. This is the beauty of images, even in their most minimal form—such as a single line. All marks, smudges, pictures, take on a life of their own and accrue meaning under the gaze of a viewer. Viewers activate the thing perceived. You can control the image but not the reaction to it.

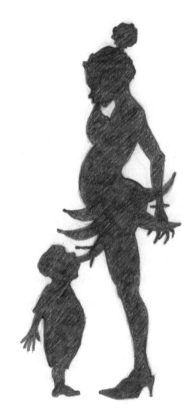

After Kara Walker

13

Each generation gets to reinvent art in its own image.

Because art is an act of description, it is inevitable that what it describes will reflect every generation's bias of the moment. It is not a strict reflection of a time but an interpretation rendered in a language that is always in a state of transformation.

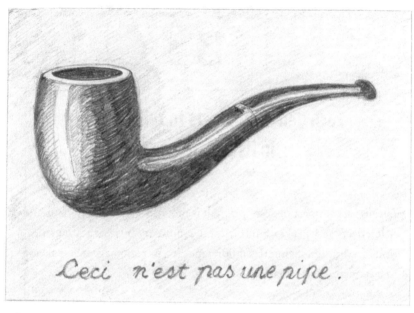

After René Magritte

14

All images are abstractions.

Even photographs. They are never the thing pictured; they are a conceptual or mechanical reproduction of a thing past. This may seem obvious, but it has everything to do with the way we perceive and use images. As pictures are symbolic assemblages of forms, recognizable or not, they are always metaphors. Metaphor is the medium of symbolic language and is the language of art. Realism in art is anything but. The greater the art, the greater the illusion.

15

"The unconscious is that which we know, or have experienced, but for which we do not have a name."

—Walker Percy, *The Message in the Bottle*

Images are catalytic as well as cognitive. This is what gives images their special power and why, through the ages, they have been attributed to have dangerous and magical qualities. Images can be retained in memory as experience.

After Christopher Wool

16

Words are images.

The power of the visual belongs to all things received visually. The written word is both symbol and cognitive catalyst; image and thought embodied. But words also conjure the image that lives only as a thought or non-embodied object. Some ideas are most potent when not embodied and exist as ephemeral, fleeting experiences. Concept has form.

Drawing is about mark making.

Every mark has a distinct character and quality. Every mark is a signature. Variation in pressure and weight is the visual equivalent of intonation. Marks, or lines, of consistent weight or thickness surrounding a figure or object will flatten the image. Tapering or breaking a line in a curve can connote a highlight or make the curve flow. Also, a tentative line will read as such. Give every mark or line authority and make sure it serves a purpose. Try to use only the marks you need.

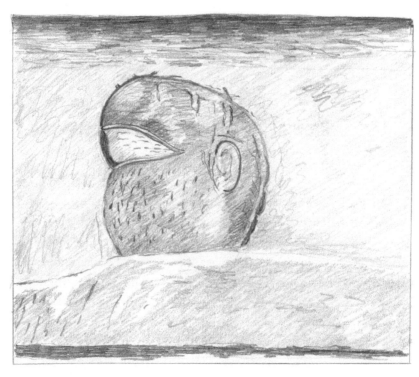

After Philip Guston

18

"You work to divest yourself of what you know."
"I want to end with something that will baffle me for some time."

—Philip Guston, *The Poem Pictures*

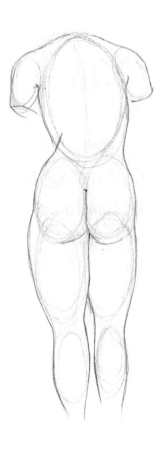

The human figure is a complex construction composed of a rigid frame overlaid with soft, rounded, elongated muscles.

Its main volumes can be described with a series of interlocking ellipses. There are no straight lines in a body. And it is symmetrical. When laying out a figure drawing, try to do it with a series of interlocking ovals. This will insure that the figure maintains its dimensionality, its roundness in space. This roundness applies to most objects in nature.

20

Clear sight makes clear art.

Observation lies at the heart of the art process. Whether your art derives from mimicking nature or extrapolating a mental construct, your powers of observation are critical. Unless you can see what lies before you, you cannot describe it. Train yourself to eliminate preconceptions and received understandings when observing anything. Try to see what is before you, not what you think you see or want to see.

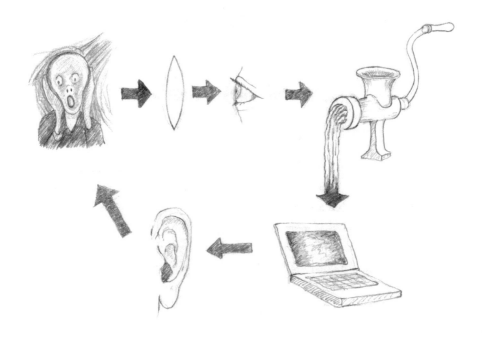

21

Experience of most things is mediated.

The majority of information that comes to us has been shaped, edited, and distorted by politics, commercial interests, customs, and the forms of its delivery. Primary experience often takes a backseat to multiple levels of intervention. Parsing these influences is a critical observational challenge. Art is, itself, a form of mediation.

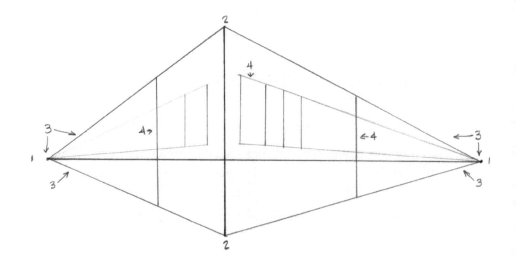

22

Learn to draw perspective.

Perspective drawing is one of the few skills that can be achieved through a formula. Mastering it is critical to the depiction of space and is a key element to all rendering. The two most basic forms are *one-point* perspective and *two-point* perspective. The "points" refer to the number of "vanishing points" on the horizon where all parallel lines converge. One-point perspective occurs when the vanishing point is ahead of you (imagine looking down a railroad track). Two-point perspective occurs when looking obliquely at an object in space where two or more sides face you.

1 Establish the horizon (your eye level).
2 Establish the vertical height of the object closest to you.
3 Establish the vanishing point(s) and draw lines radiating from those points to the lines establishing the vertical height(s).
4 Fill in all other vertical elements and make sure all horizontal elements project back to the vanishing point(s).

After Southern Sung painting

23

Not all images operate with the same perspective system.

Asian painting employs a shifting perspective as well as an axonometric projection: parallel lines with contrasting thirty-degree angles but no vanishing points. It is a nonlinear system that is based on concept and convention rather than trompe l'oeil spatial illusion. As such, it acknowledges that all visual description is a form of abstraction.

After Kasimir Malevich

24

All art is political.

The choices you make in what you describe, and the medium you choose, will always be subject to an interpretation that has political implications. The choice to make work devoid of any explicit social content speaks as much of the maker's world and aspirations as a work that carries an overt political agenda. All art is a reflection of choices made—omissions as well as submissions. The world your work describes is the world that you, as a maker, promote.

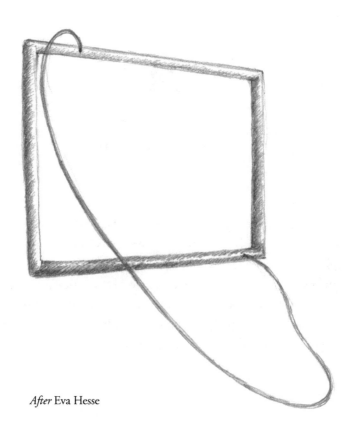

After Eva Hesse

Style is the consequence of something being described in the way most appropriate to its content.

It is not a hemline height or a gratuitous decorative flourish added to modify or embellish an image. Style is the by-product of saying what has to be said in the most appropriate way a maker can say it. Meaningful style emerges from the necessity of description; it is not a product of self-conscious selection.

After Arshile Gorky

26

Abstraction comes from the world.

It is less a distillation than it is an accretion. The material world impresses upon us images and patterns from the first moment we open our eyes. Composition, harmony, proportion, light, color, line, texture, mass, and motion are all part of the vocabulary of sight. We tap this vocabulary, and the patterns that go with it, when we compose or frame images. The commonality that allows us to respond to images, even abstract ones, is rooted in our ability to recognize infinite manifestations of the physical world and the mental constructs to which they correspond.

After Myron Stout

27

Figure and ground.

Most images, even abstract ones, usually have a figure, the object(s) of interest, and a ground, the space in which those objects sit. This holds for video and film as well. The relation of the figure to the ground is the most basic compositional device and describes to the brain the most basic conditions of any image.

After Paul Klee

28

An idea is only as good as its execution.

It is important that you master your medium. Poorly made work will either ruin a good idea or make the lamentable execution itself the subject. Overly finessed technique can mask a lack of content or can smother an image. At the same time, roughness and imprecision has its place in rendering. One can only gauge the need to throw technique away if one has first achieved the mastery of it.

After Willem de Kooning

29

"Conception cannot precede execution."

—Maurice Merleau-Ponty, *Sense and Non-Sense*

Art is a process of discovery through making, and our ability to discover is generally greater than our ability to invent. Think of your work process as a form of travel. Look for the things you don't know, the things that are revealed or inadvertently uncovered. It is easier to find a world than to make one.

After Ad Reinhardt

30

For every hour of making, spend an hour of looking and thinking.

Good work reveals itself slowly. You cannot judge a work's full impact without hours of observation. It is also a good idea to step away from what you are doing at regular intervals. The immediate impression a work makes when it is reencountered is critical. A good work is satisfying both upon immediate encounter and after long periods of concentrated viewing. If any work fails on either approach, keep trying until you feel satisfied that you have succeeded on both counts.

After Cy Twombly

31

What happens in the studio should be a conversation, not a monologue.

That conversation is between you and the image you are constructing. Search for the image's inner logic and allow yourself to respond to it; try not to impose upon the image ideas that don't fit the direction the conversation is heading. An image may contain information that arrives without your conscious understanding of how it got there. If you aren't engaged and observant, you might miss it or work over it.

After first-century Izapan altar

32

Context determines meaning.

The social or cultural space in which an event occurs or an object resides imbues it with particular meaning. Medium, also, carries its own historical baggage that shapes the discussion of its content. Context is slippery. A performance in a gallery can become political activism on the street. Context is a boundary changer.

After Caravaggio

33

Chiaroscuro is the dramatic contrast of dark and light in an image.

Caravaggio and Rembrandt are considered the early masters of the technique. In addition to creating startling visual effects and highly charged emotionality, chiaroscuro enhances the volumetric quality of figures and objects since it is through the contrast of light and dark (value) that we are able to perceive volume. The effect of chiaroscuro applies to time-based media as well as static images.

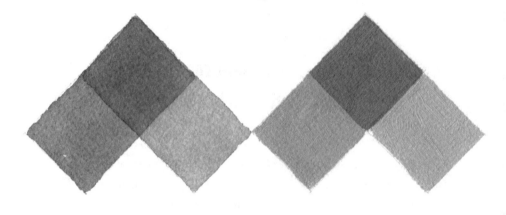

TRANSPARENT OPAQUE

Transparent and opaque media operate in different ways.

Transparent media, such as watercolor and water-based acrylics, work from light to dark; shadows are applied last and highlights are created by the white of the ground remaining untouched or lightly covered. An opaque medium, such as oil, works from dark to light. In traditional oil painting, a dark ground provides the deepest shadows and highlights are applied last, providing a literal depth to the surface due to the buildup of pigment. Wet-on-wet painting in oil or acrylic may give a variation of this, but still, the highlights are generally applied last.

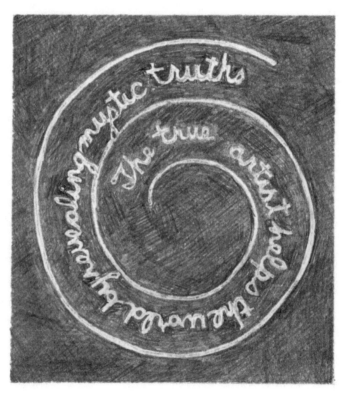

After Bruce Nauman

<div style="text-align:center">

35

</div>

"Sincerity is a non-value in art."

—Robert Storr, lecture at Pratt Institute

Once a work of art leaves the studio and arrives in the larger world, your sincerity is a weak predictor of the work's success. Outside of the studio, your work must stand on its own and reveal itself without your being present to defend or explain it. A sincere artist can make weak work, and an insincere artist can produce masterpieces. Don't try to defend a work's shortcomings with protestations of good or sincere intentions. It isn't part of the of the larger world's criteria of judgment.

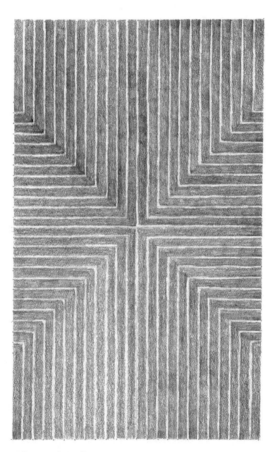

After Frank Stella

36

Don't just make designs—say something.

Pleasing design alone does not make interesting art. Design is only the first step in making something substantive and convincing. To succeed, an image must lead to something beyond the mechanics of formal arrangement. It must be integral to a larger discussion about the world in which it was created, and the history of its own form. Meaningful abstract images (which are most closely associated with pure design) speak to the issues of their time and the history and future of their form.

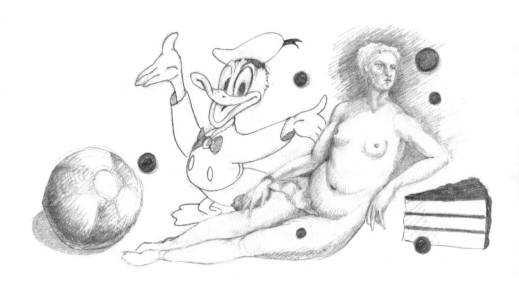

37

Multiple unrelated images, combined into a single image, do not necessarily create complexity.

Unrelated images put together in the same space may be nothing more than unrelated images in the same visual field. It is the relationship of those individual images to each other, and what those relationships describe that creates content. Collage and pastiche have become commonplace and easy in the digital world. Creating visual interest through the juxtaposition of unrelated images may not successfully create a complex description or coalesce into a unified affect.

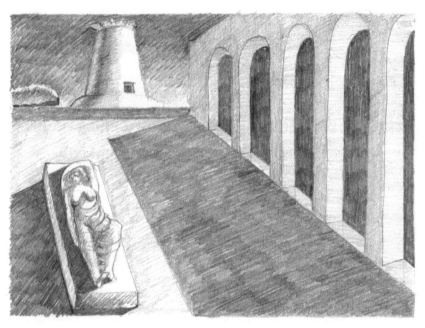

After Giorgio de Chirico

38

Complexity derives from the presence of contradiction.

The world is not simple. It is rife with complexity. The impulse to eliminate the contradictions that create complexity is natural. But to simplify may be to render a false condition and therefore an incomplete description. Embrace the irreconcilable elements, the contradictions. They are part of any portrait of a moment.

39

Form is limitless.

It is a state of pure possibility until it is defined. Form exists in an op-
positional relationship with formlessness. The dissolution of form is
not only a powerful compositional device but is also metaphorically
potent. Form accommodates a need to embody an idea or a perception.
Formlessness challenges that very need and questions our sense of the
immutability of things as we know them. Form is a vessel. It can be
open or closed.

After Ana Mendieta

40

Making art is an act of discovery.

If you are dealing only with what you know, you may not be doing your job. When you discover something new, or surprise yourself, you are engaging in the process of discovery.

After Louise Bourgeois

Porosity, not solidity, now defines our view of the world.

Before the twentieth century, the world was viewed as solids operating within space. But now, we see the world as consisting of unstable patterns, porous membranes, and merging states. Microwaves go through our bodies and dense masonry walls, ideas migrate from public to private realms, from studio to store, from one medium to another. Containment, whether of information or of material, concept or emotion, is difficult. Our world now is porous on every level.

After Vito Acconci

42

Art has no boundaries except those imposed by the needs of the maker.

Boundaries are a form of definition, nothing more. They are a way to create a hierarchy of concerns, interests and priorities. Boundaries change all the time. That is part of what art does. By defining an area of interest or by stating a new priority, art allows us to create new definitions of ourselves and the context in which we operate. To blur a boundary is to confuse the definition. To move a boundary is to make a new definition.

After Allan McCollum

Simulacrum refers to a likeness or simulation that has the appearance *but not the substance* of the thing it resembles.

Virtual reality, virtual experiences are based on simulacra. Politics and consumerism are also based on simulacra. Most of what passes for communication and, to a large extent, the objects we collect and consume are all copies of something we will never experience as an original. The disconnect between what we know as image and what we experience, materially or actually, constitutes a large part of what must be the description of the world we know. Parsing that difference is a critical part of describing the world that surrounds us.

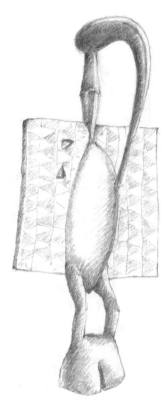

After nineteenth-century Senufo bird

<div style="text-align: center;">

44

</div>

The human brain is hardwired for pattern recognition.

It has the capacity to distinguish tens of thousands of variations of the human face, which is composed of slight differences in a small set of features. The brain looks for what it knows. This has an upside and a downside. It makes it possible to create a recognizable image with very crude means. But it also makes it more difficult to render the world new or unfamiliar. To make an image different enough to bypass the brain's pattern recognition and force it to reassess the meaning of an image is a challenge for every artist. To make the familiar unfamiliar is a large part of making new visual language.

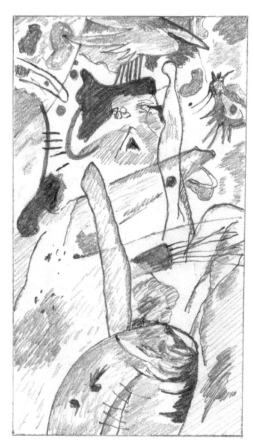

After Wassily Kandinsky

Work from your intuition, and analyze with your intellect.

To keep your work spontaneous and inventive, try to draw upon what lies beneath normal cognition in an uninhibited way. Intuition is not hocus-pocus. It is simply a judgment system that operates without immediately available conscious evidence. Intuition draws upon subliminal knowledge and allows the unfiltered, unfamiliar, and unknown to enter your work. Once there, you can apply your powers of rational analysis to discover what you have done. At this stage, you can always edit, but don't edit or preclude what does not yet exist.

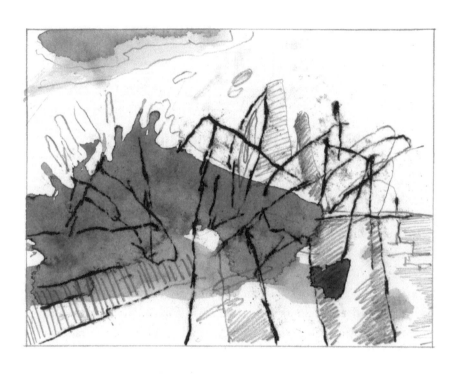

46

Embrace the "happy accident."

All forms of painting, film photography, sculpture, printmaking, and nonmechanical modes of production produce unintended results. When a passage of underpainting looks ravishing, or some studio calamity produces an arresting effect, embrace the accident and incorporate it into the piece. Exploit the unexpected consequences of experimentation and process. If you see it, own it.

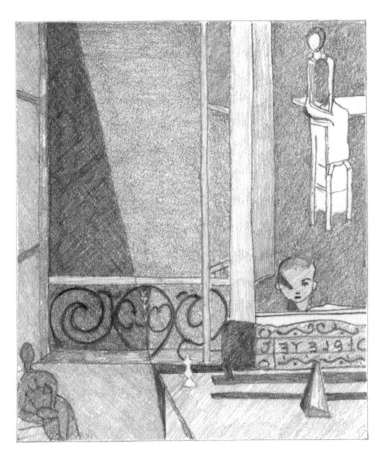

After Henri Matisse

47

"The importance of an artist is to be determined by the number of new signs he introduces into the language of art."

—Henri Matisse, quoted in *Matisse* by Louis Aragon

Art is a language of signs and symbols. To describe new conditions, new signs must be created or old symbols must be redeployed in ways that give them new meanings. Given that the world is constantly changing and that each new generation describes the world it sees in its own way, the symbol language of art must always be evolving. Language is influence.

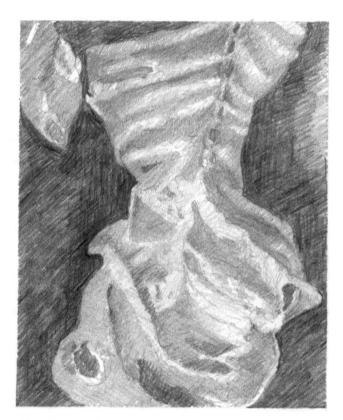

After Chaim Soutine

<div style="text-align: center;">

48

</div>

Facture refers to the manner in which a painting, drawing, or object is made.

It is the combination of brushstrokes, marks, material, and the texture of the surface. Facture is critical to the success of any object. Much of the fascination that accrues to all manual media comes from what can be observed at close range. That distance reveals the foundation, the touch, the sensuality, and the understanding of the material that gives art objects their essential character.

After Susan Rothenberg

With opaque media, learn to mix colors on the surface of the image.

Premixing color completely on a palette or table before application can lead to a flat or paint-by-numbers effect. Learn how colors react to each other when mixed, and use that knowledge to meld colors together on the painting surface while you are working the image. Mixing too many colors together will produce something that resembles mud, so experiment with the effects of mixed color. This will give the image a more spontaneous and fresh aspect and add to the dimensionality of whatever is depicted.

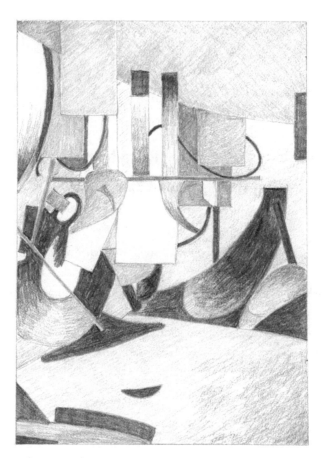

After Francis Picabia

50

Formalism refers to judging a work of art based on the elements of its visual language: form, line, color, and composition.

An abstract work, whose only subject is the elements from which it is constructed, is the prime example of a formalist work. But naturalistic works with recognizable subjects or allegories may also be formalist works if their prime significance derives from the presentation of their form rather than their content. Allegories, whose stories remain the same from artist to artist, are often discussed formally since the content often remains the same. The classic summation of formalist orthodoxy is "form is content." Marshall McLuhan's adage, "the medium is the message," can be viewed as a twist on this concept.

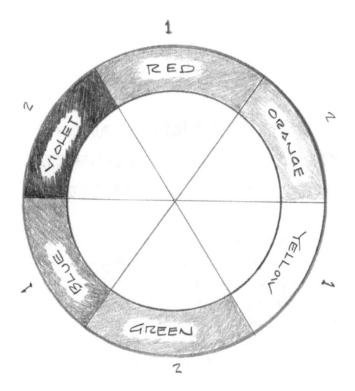

51

Learn the basic principles of color.

There are three primary colors: red, blue, and yellow. They are the building blocks of all other colors. The secondary colors are violet (blue and red), green (blue and yellow), and orange (red and yellow). They are composed by the equal mixture of two primaries. All other colors are referred to as tertiary, because they are mixtures of a primary and a secondary color.

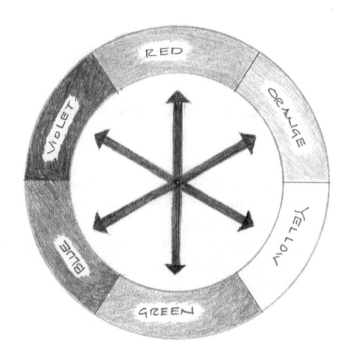

52

Every color has an opposite, called a *complement*.

Complementary colors sit opposite one another in the color wheel. Additionally, all colors are affected by the presence of other colors. Even the smallest presence of a complement will enhance the intensity of a color when it is present in the same visual field. The presence of red, for instance, will cause the retina to "seek" green in the other colors present, hereby enhancing all parts of the green spectrum. If you wish to intensify a color in a composition, place some of its complement nearby. This applies to all media. The effective use of color is one of the greatest tools at an artist's disposal.

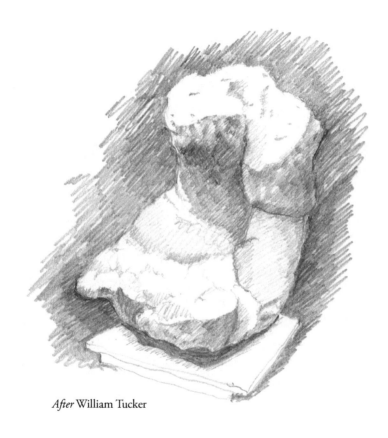

After William Tucker

53

Sculpture occupies the same space as our bodies.

Its physical presence is different from a two-dimensional object. Sculpture challenges and confronts us physically. It is not dependent on the spatial illusion present in most two-dimensional work, even abstraction. Sculpture never has to justify its reality. It simply is. Physical presence is a form of power.

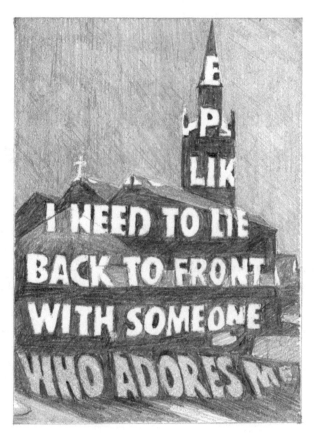

After Jenny Holzer

54

Time is an essential element in all media.

Time reveals itself in two critical ways: the unfolding of the form and the experience of the viewer. Real-time duration implies a narrative structure or linear path, even if abstract, and delivers information and experience in measured units (film, performance, and video). In those cases, the viewer becomes a passive receiver. Recorded media, video, film, L.E.D. word displays, and computer simulations allow for the manipulation of time and the creation of temporal illusion. Time is a dimension.

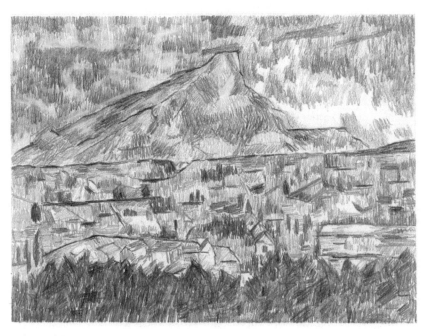

After Paul Cézanne

<div style="border: 1px solid black; display: inline-block; padding: 20px;">

55

</div>

Static images deliver the information they contain instantly.

But they also have the capacity to reveal the whole process of their making, as well as the depth of their narrative, over an extended period of investigation, meditation, and analysis. Paintings are especially unique in this quality. Good art never stops revealing itself. And though the eye can take in an image in its totality in an instant, great images reveal their secrets slowly. The more complex an image, the slower the revelation.

After Richard Serra

56

In all good work, the image and its medium are inseparable.

In a successful painting or drawing, every mark has an equal but dual identity as both a stroke of paint and a part of the image the stroke creates. The material and the image should be one. A Serra sculpture *is* the steel that makes it. And it finds its identity both as steel and sculpture without conflict. Your medium should be an expression of your image, and your image should arise from its medium.

Digital space, analog space, and manually rendered space have different qualities.

Digital space is an electronic abstraction, created from a sampling of visual information translated into a binary language. It is then reassembled as a pure simulation. Due to its additive, artificial color, its high contrast, and the characteristics of the screens on which it is viewed, digital space may read as somewhat flat. Hand-rendered space, because of its subtractive color, its tactility, and its variability of effects, can be flat or convincingly illusionistic. Analog space, the product of film, takes on different characteristics due to the distortions of the lenses used. Know the characteristics and qualities of each, and use them to their best effect for the image you want.

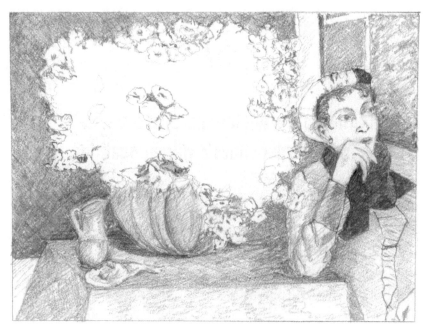

After Edgar Degas

58

Photography forever altered our compositional sense.

The camera, with its viewfinder that samples a portion of the world, changed our relationship to the frame. The understanding that the frame is artificial and that the world extends beyond it affects the way we compose images. Painters, such as Degas, allowed the frame to cut into figures and objects, implying that part of the subject lay outside of the view of the image. This was a radical change from the centered image of traditional painting where the space inside the frame was a metaphor for the world. Now, we see the edges of pictures as being vital and compositionally active, not dormant and arbitrary.

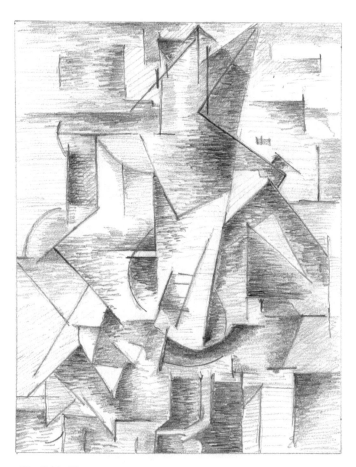

After Pablo Picasso

<div style="text-align: center;">

59

</div>

Depicted space may be continuous or discontinuous.

Continuous, or traditional, space, creates a logical reading of the world as we perceive it and is dependent upon illusion and wholeness. Discontinuous space is fractured and non-illusionistic. Cubism and other forms of flattened, abstract space are discontinuous in that they imply different spaces occurring simultaneously in a single visual field. This fragmentation of space was symbolic of what modernists saw as the disruption of the modern world with its assault of simultaneously occurring events. We have come to take this as a given in contemporary life. With the complete integration of time-based media, film, animation, and electronic games into the daily fabric of our lives, virtuality has overcome the association of continuous space with traditional art and made it possible to see space as an interchangeable element in the vocabulary of art.

```
A      PLACE
A      TIME
A      CONDITION
AN     EVENT
A      PERSON
AN     INTENT
AN     ACTION
A      RESULT
```

60

Information is a medium.

Though ephemeral, and without the materiality of oil paint, a silver gelatin print, or a hunk of clay, information must now be considered the stuff of which art can be constructed. Until it is harnessed to an agenda, analyzed, and used to make a coherent description, however, it is just data. Think of information as a brushstroke that is used to make a larger image. Unlike physical media, information is perishable and becomes dated. It should be used, therefore, like all media, to embody the metaphorical.

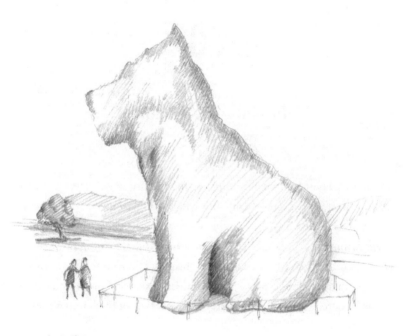

After Jeff Koons

"The whole of life of those societies in which modern conditions of production prevail presents itself as an immense accumulation of spectacles. All that once was directly lived has become mere representation."

—Guy Debord, *The Society of the Spectacle*

We now confuse productions for documentation, entertainment for news, image or hearsay for direct experience. Art operates in this arena and plays a role in identifying our relationship to the illusions and the actualities that surround us.

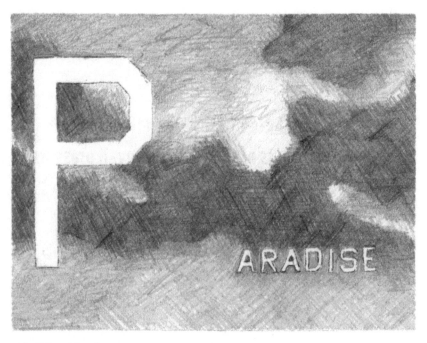

After Edward Ruscha

62

Illustration versus autonomy.

Illustration is a visual aid to a text or an idea and is subservient to that primary agent. Fine art, while it may illustrate an allegory or concept, has always attempted to maintain its role as primary vehicle; an autonomous form embodying the text. This subtle distinction has eroded over time but still plays a role in our judgment. This is part of art's nonutilitarian identity.

DESCRIBE COMPLETELY, AND IN DETAIL, WHAT YOU SEE,
AND ONLY WHAT YOU SEE, IN YOUR WORK.

ASSESS THE LITERAL OR METAPHORICAL CONTENT THAT
YOU SEE REVEALED IN YOUR DESCRIPTION.

TRACE THE INFLUENCES THAT GAVE BIRTH TO THE CONTENT
YOU SEE.

AVOID INTERPRETATIONS OF WHAT YOU MAY THINK OR FEEL
BUT WHICH IS NOT PRESENT IN THE ACTUAL WORK.

DESCRIBE HOW THE WORK'S CONTENT IS REVEALED BY ITS
FORM AND HOW ITS FORM IS DICTATED BY ITS CONTENT.

↓

WEAVE A DIRECT, COHERENT NARRATIVE THAT TELLS THE
STORY UNCOVERED BY THE ABOVE.

63

Learn to speak about your work.

This not only helps those who are looking at your work to understand what you are trying to achieve but also is critical to your own understanding of what you are doing. Avoid trying to interpret your own motivations or what may lie behind your work. This is an invitation to mislead yourself or read into the work something that is not there. The work is the starting point, and ending point, of its content.

64

Art is a form of experimentation.

But most experiments fail. Do not be afraid of those failures. Embrace them. Without courting the possibility of something miscarrying, you may not take the risks necessary to expand beyond habitual ways of thinking and working. Most great advances are the product of discovery, not premeditation. Failed experiments lead to unexpected revelations.

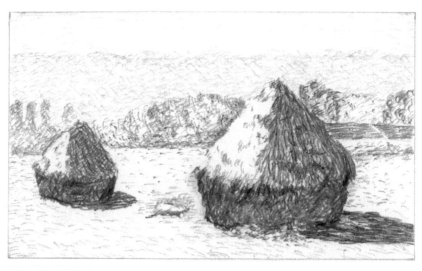

After Claude Monet

65

A painting should be satisfying at a distance of both twelve inches and twelve feet.

At the shorter distance, the facture should establish the painting's integrity and be sensually satisfying. A confused or poorly constructed surface signals lack of command of the medium. At the greater distance, the composition of the whole needs to reveal itself as a convincing and meaningful assemblage of information. Rework the painting until it can pass this test.

66

We are able to see things three-dimensionally because of contrasts of value.

The strength of light makes depth perception possible through the creation of shadow. As value contrasts diminish, so does our ability to see depth and the fullness of objects. At dawn or dusk, our depth perception diminishes. To enhance the illusion of depth and the dimensionality of objects, enhance the contrasts of value, especially between highlights and shadows.

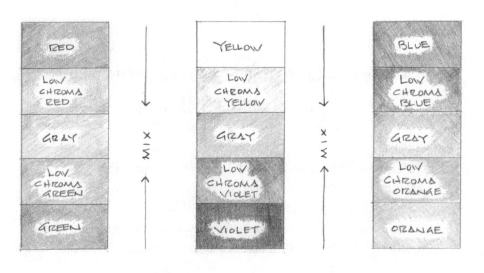

RED		YELLOW		BLUE
LOW CHROMA RED		LOW CHROMA YELLOW		LOW CHROMA BLUE
GRAY	MIX	GRAY	MIX	GRAY
LOW CHROMA GREEN		LOW CHROMA VIOLET		LOW CHROMA ORANGE
GREEN		VIOLET		ORANGE

COMPLEMENTARY MIXES

67

Chroma is the intensity, or saturation, of a color.

The purest state of a color represents its highest chroma. To lower the chroma of any color, add a small amount of its complement. All complementary colors (opposites), when combined, create neutral gray that sits at the center of the color wheel. Low chroma colors are among the most complex because they contain many colors and are changeable when in the presence of other colors.

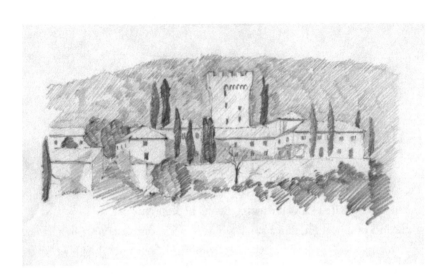

68

Lines of the same weight and density, colors of a similar tone, or comparable textures will tend to occupy the same visual plane in space and create the sensation of flatness.

To make elements occupy different planes to create an illusion of space, enhance the contrast between elements. Bolder elements advance to the surface and lighter elements recede. To create a sense of deep space with color, lower the chroma and lighten the value for things in the distance. This is referred to as *atmospheric perspective.*

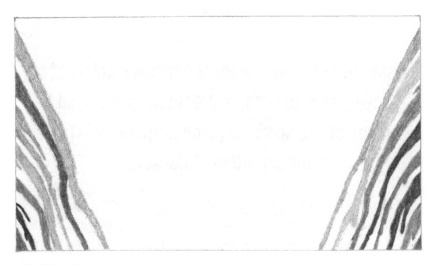

After Morris Louis

69

Color is not neutral.

It has an emotional component. Certain colors have specific associations and induce certain responses. Learn what they are. When you use color, try to determine and understand the accompanying emotional response and how to use it effectively. Color has a visceral impact.

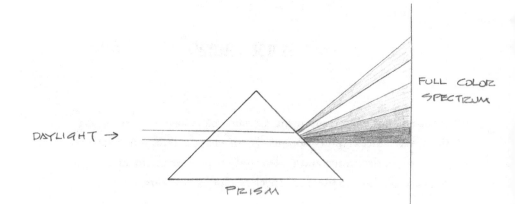

DAYLIGHT →

PRISM

FULL COLOR
SPECTRUM

70

Color is light.

Light is color. Every ray of sunshine contains within it all of the colors we can see. Likewise, as light fades the amount of color we can see diminishes. In early dawn, at dusk, or under moonlight, there is little color. This is why the quality of color is directly related to the light that reveals it.

INCANDESCENT FLOOD:

ORANGE/PINK LIGHT

FLUORESCENT:

BLUE / PINK OR FULL
SPECTRUM LIGHT

HALOGEN:
FULL SPECTRUM "WHITE" LIGHT

71

The light under which you work affects whatever you do.

All light contains color and different kinds of light sources affect not just what you see when you are working but how a work will look under other light sources. Natural light carries a full spectrum of color, but incandescent and fluorescent lights, except those designated as "full spectrum," will "color" what you see under them. Even if you work in black and white, values can change under different light sources. Whenever possible, work with full-spectrum light sources.

After Tino Sehgal

72

Experience can act as an object.

Art has traditionally been object oriented. But with the emergence of performance, installation, sound- and time-based media, ephemeral experiences and relationships can now be thought of as surrogate objects embodying the art impulse. This is in keeping with the fleeting and disembodied nature of much of what passes for objecthood in the simulated realm of the digital. Objects must be thought of as pulses of energy and patterns, not just solid volumes.

Pollux & Castor

Object as a protest against
immateriality & ephemerality.

Cumuleum

Via Appia
1.12

73

Carry a sketchbook or journal.

Ideas and images can be fleeting. It is important to capture them when they occur to you. Never trust that the great revelation will hang around in your memory. Record it at the moment of encounter.

Learn from your fellow students.

People enter art school with diverse talents. As observation is at the heart of art practice, observe your peers. It is your mutual world and its concerns that you need to describe. Your peers are an invaluable resource. Emulate the things they do well, and learn from their mistakes and their successes. This lesson lies at the heart of critique. All artists borrow from each other's discoveries and failures.

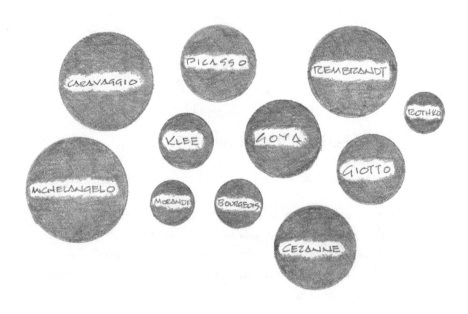

CARAVAGGIO
PICASSO
REMBRANDT
ROTHKO
KLEE
GOYA
MICHELANGELO
GIOTTO
MORANDI
BOURGEOIS
CEZANNE

• ← ASPIRING
 ARTIST

75

Humility is critical to honest evaluation.

An idea or image is not interesting just because you make it or are obsessed with it. All ideas and images need to be considered in the wider world of opinion. This is one of the larger opportunities art school offers—the chance to test your ideas against others who have capacities for visual thinking. Being too sure of the value of your own work will keep you from doing what is necessary to hone your technical skills and your analytic capacity.

76

Avoid clichés and one-liners.

Unless you are using a cliché ironically, it may lead to a meaningless piece of work. One-liners are often as dependent on timing as substance and lose their potency with repeated telling. Try to avoid shopworn images, such as a crying baby as a symbol of vulnerability. Clichés and jokes provide instant accessibility but fade quickly.

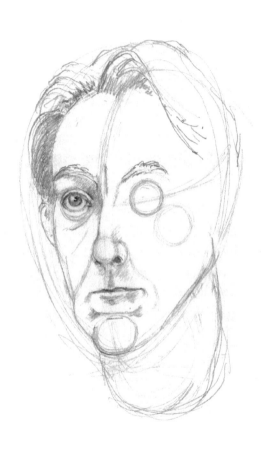

77

The human face is not flat.

It is composed of a series of overlaid spheres: the eyes, the cheekbones, the nose (three small spheres at the end of a stick) within a larger egg-shaped head. Understanding this will help you capture the complex dimensionality of the human face and avoid turning it into a flat mask.

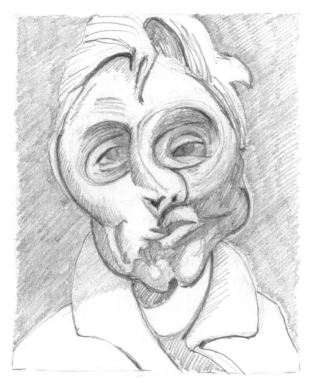

After Francis Bacon

78

Self-portraiture has a long and storied history.

It is something that most artists undertake in their training. It can yield great revelations of character and technique as in Rembrandt, van Gogh, and Bacon. It will succeed or fail based on its interest as an image. Try to judge it as an image, not as a mirror.

After Pipilotti Rist

79

Hybridity defines the art process.

It describes the cross-pollination of areas of study, disparate types of experience, and the polyglot nature of the globalized world. To embody this glut of atomized experience, art incorporates multiple media and points of view, often together. Purity of medium or message may not describe the world around you.

After Hans Hofmann

<div style="border: 1px solid black; display: inline-block; padding: 10px;">

80

</div>

Two-dimensional images contain a capacity for spatial illusion.

This is what separates flat media from objects or sculpture. Even abstract images, by virtue of the interaction of color and form, can create the illusion of space.

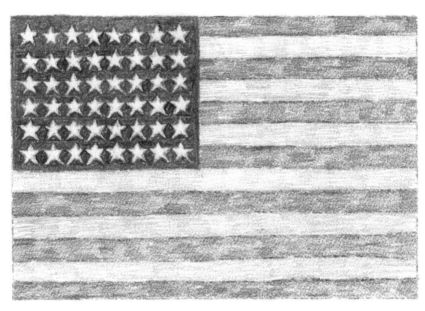

After Jasper Johns

81

Art is apprehended through the senses as well as the mind.

The emergence of conceptual work has not removed the place of the senses in the affect of art. Texture registers visually. Images can produce adrenaline, as can sound and motion. Scale determines our physical approach to an object. We still react to the world as animals. Our bodies are receptors.

After Urs Fischer

82

Space has social and cultural dimensions.

Whether public or private, space is laced with signifiers of use and is a vessel for both social discourse and private associations. Installations, by inhabiting space in directed ways, alter and call attention to how space accrues meaning and transmits it to those who enter it.

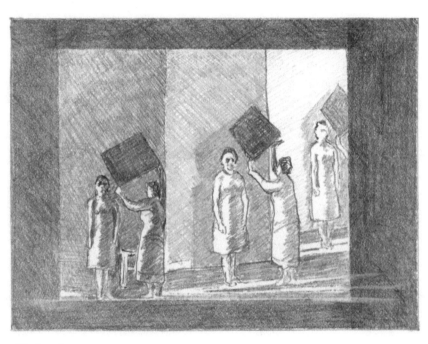

After Joan Jonas

83

Performance is a form of process, acted out in real time.

Part theater, part dance, part documentary action, it also partakes of the formal issues that have traditionally governed the static arts of painting, sculpture, and architecture: form and movement enacted in space.

After Donald Judd

84

All media are delivery systems for content.

With so much emphasis placed on information technology, it is easy for the delivery system to overwhelm the content or render it insubstantial. Technology becomes obsolete. Give your content primacy of place, then find the medium to deliver it most effectively.

85

The studio is more than a place to work: it is a state of mind.

It is the place where your practice is established, and the place where you experiment and meditate on the results. Whether it is a room or a computer, the studio is your locus as an artist.

86

Objectivity is largely an illusion.

Even media that aspire to factual documentation are inflected with the predilections of the eye behind the lens—a bias. And the context in which art objects operate removes them from any identity they may hold in the larger world. The art process is subjective.

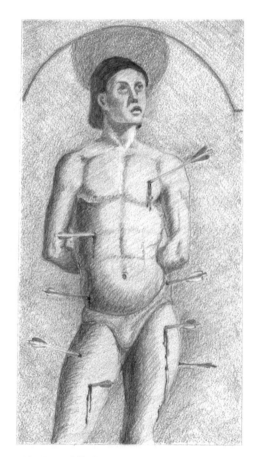

After Piero della Francesca

87

Learn to accept criticism.

Critique is the foundation of art school education, and learning to make constructive use of it is one of the most difficult and important lessons to absorb. Look at your own work, and the work of others, as dispassionately as you can. Being defensive or hurt, while a natural reaction, will not help you improve your work. Learn the biases of your instructors so that you make the most use of their comments. Disagreeing with criticism is not wrong, but unless your work succeeds on its own merits in the eyes of your instructors and peers, resistance may not be constructive or helpful. Be brave under fire.

After Barnett Newman

<div style="text-align: center;">

88

</div>

Understand the implications of the "intentional fallacy."

Once your work leaves your studio, it will be judged on what viewers find there. If your intention is not manifested in the body of work itself, it is of little consequence. You will not be present to explain it and defend it. Viewers, and posterity, have the last word on a work's meaning.

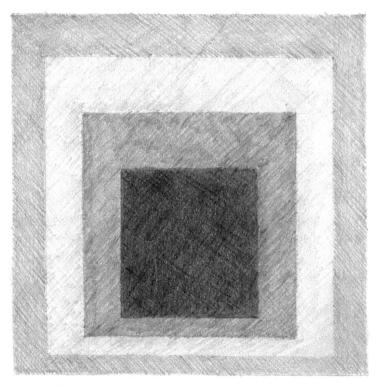

After Josef Albers

$$\boxed{89}$$

Eliminate the nonessential.

Every work of art should contain whatever it needs to fulfill its descriptive objective but nothing more. Look at the "leftover" parts of every composition. Successful images have no dead spaces or inactive parts. Look at your compositions holistically and make sure that every element advances the purposes of the whole.

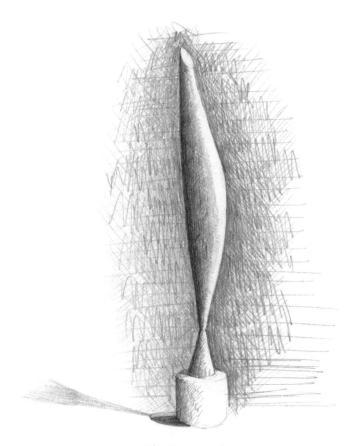

After Constantin Brancusi

90

"You can condense, but you cannot simplify."

—Ann Lauterbach, personal conversation

The world is infinitely complex, and any attempt to simplify, which means the elimination of contradictory elements, will fail to capture that complexity. One can, however, attempt to compress or condense those elements into a more abbreviated or altered form. That is the role of metaphor.

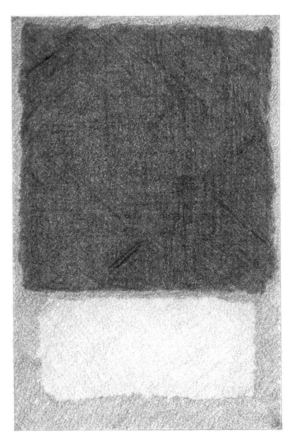

After Mark Rothko

91

Scale is a critical component of any work.

Images, or objects, smaller than the upper torso of one's own body tend to operate in "metaphoric space." We enter or inhabit these spaces mentally, imaginatively. Images or objects that are the size of the body or larger, invoke an actual space, and we tend to relate to these spaces viscerally, somatically, theatrically. Choose the scale of your work according to what you feel is most effective for the image and be conscious of the response the scale will evoke. Inappropriate scale can diminish or crush an image's affect. Work in different scales to better understand its effect on your work.

92

The shape of an image carries a hidden metaphor.

Horizontal rectangles imply a horizon and, therefore, invoke landscape. Vertical rectangles summon associations with the body's own perpendicularity to the earth and, therefore, imply the space of a figure. A square is a neutral space. Irregular shapes will follow the same principle.

93

Cultivate your idiosyncrasies.

Every hand, every eye, every brain comes with its own built-in distortions. These distortions represent your signature, your personal slant on the world. When they manifest themselves in your work, do not be afraid to embrace them as long as they do not represent an impediment to some larger objective or overshadow everything else the image contains.

After Roy Lichtenstein

94

Irony has controlled the stage in contemporary art since the end of Modernism.

Non-ironic work has found a refuge in the political and sociological but is an endangered species in formal, visual art. To avoid the twin whirlpools of the easy send-up on one side and the sentimental on the other, come to a clear and meaningful understanding of how irony reveals itself as a serious factor in the world. As Richard Rorty once wrote, it is the recognition of "the contingency of all things."

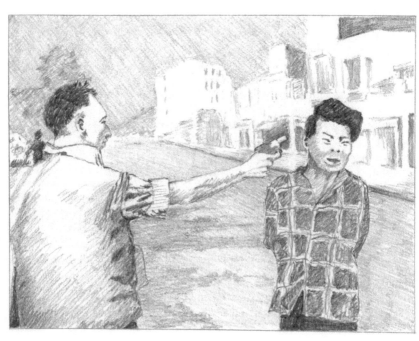

After Eddie Adams

95

The lens is a distancing agent.

It puts everything viewed through it at a remove. Because we have become accustomed to seeing so much through the lens, much of what we consider "experience" is, in fact, mediated by the lens's particular qualities. Images borrowed from photographs or videos will carry the subtle effects of the distance and detachment the lens creates. Be conscious of the way this affects the images you make. If immediacy is a goal, it may have to be achieved through different means, such as direct observation.

96

Document your work.

A good photo archive is a necessary part of your professionalism. Digital photography makes this easy. You may even find it useful to keep a record of the stages of your work. Because a good working process allows for "happy accidents," it is good to record those lest you work over them before you realize their value. It is also necessary to have a good record of images for school, for grant applications, gallery presentations, and your own history. A good image archive is also a useful source from which to draw ideas for future work.

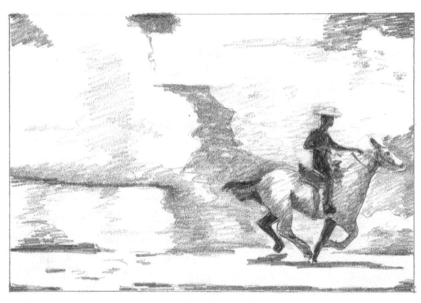

After Richard Prince

97

Every borrowed or appropriated image carries an agenda.

That agenda belongs to its original maker. If you are making collages from borrowed images or appropriating images for your own purposes, be aware that in order to make it yours, you must subvert its original agenda. Otherwise, that initial agenda will remain and override yours.

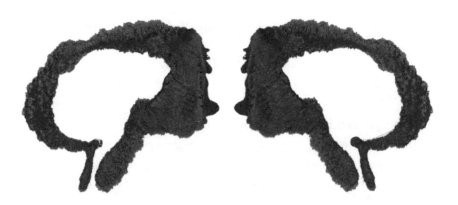

98

Meaning does not exist in the singular.

It is a transaction between two or more conscious minds. Your work is an attempt to bridge understanding between you and others. For this reason, there is no such thing as private symbolism. Meaning derives from communication.

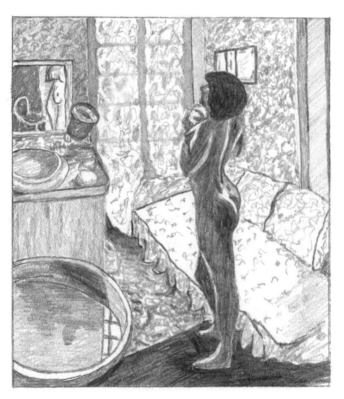

After Pierre Bonnard

99

Admire your forebears, but don't try to build a career by repeating their discoveries.

Most students come to art training after a passionate engagement with established or historical art. Nothing is more thrilling than to delve deeply into the beauties of Titian, Turner, Rodin, or Cézanne or into the edgy excitement of contemporary work. But every student must remember that art is a constantly tilled field, and its job is to overcome what we know in order to examine and celebrate what we don't yet know. What makes work of the past endlessly satisfying is the vistas it provides into a moment in history. Every artist must do the same for his or her moment.

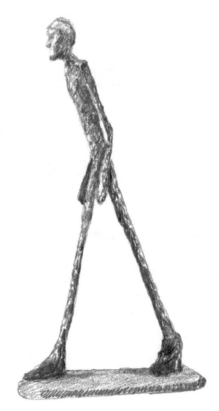

After Alberto Giacometti

Art is the means by which a culture describes itself to itself.

Those descriptions, in turn, form our sense of how we see ourselves in the present and in relation to the past. Art cannot feed us, shelter us, or cure physical illness, but it is critical to our sense of our own humanity. It embodies our ideas and sensibilities. Art identifies and investigates the culture that produces it and examines it in relation to other cultures and other histories. Our art is who we are. This is the job for which you are training.

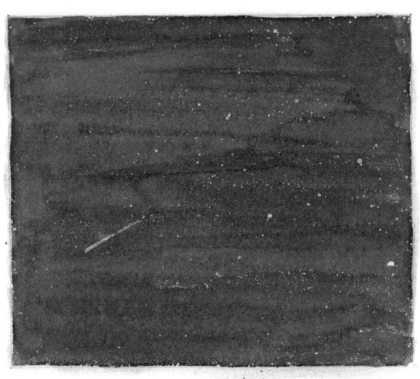

After Vija Celmins

101

Not every art school graduate becomes a successful artist.

But the training one receives in art school opens avenues to the whole world. Art school teaches one to observe carefully, describe precisely, find solutions to problems through experimentation, keep an open mind to all possibilities, and to accept withering critique in the pursuit of the not yet realized. These are the skills of adventurers, visionaries, and builders of a future we cannot yet fathom.

Illustrations

(All illustrations drawn by Kit White)

Kit White is a New York–based artist who is an Associate Professor in the MFA Program at Pratt Institute in Brooklyn, New York. He studied fine arts at Harvard University, and his work has been the subject of numerous one-person exhibitions in New York and beyond. He is married to the writer Andrea Barnet, and they have one daughter.